THE SEARCH FOR FOREVER AMBER

Presented to the '81 Club

Monday, 20 March 2006

by **Mrs. Alan R. Marsh**

Text @ 2015 by JOAN'S eBOOKS LLC

All rights reserved. No part of this Kindle Edition or Paperback text may be reproduced in any form without permission in writing from JOAN'S eBOOKS LLC except by a newspaper or magazine or on-line reviewer who wishes to quote brief passages in a review.

ISBN: 9781520792781

Contact Joan Marsh at email: joanmarsh@aol.com

JOAN'S THRILLING READING LIVING VICARIOUSLY Series
https://www.ebooksbyjoanmarsh.com/

JOAN'S CHARACTER EDUCATION PICTURE BOOKS for CHILDREN Series
https://www.childrensebooksbyjoan.com

JOAN'S AMAZON AUTHOR PAGE
https://www.amazon.com/author/joanmarsh

JOAN'S FACEBOOK PAGE and TWITTER ACCOUNT
https://www.facebook.com/people/Joan-K-Marsh/100011486057355
https://www.twitter.com/@joanmarsh3

Book Interior Design & eBook conversion by manuscript2ebook.com

Volume Number Two

The THRILLING READING LIVING VICARIOUSLY Series

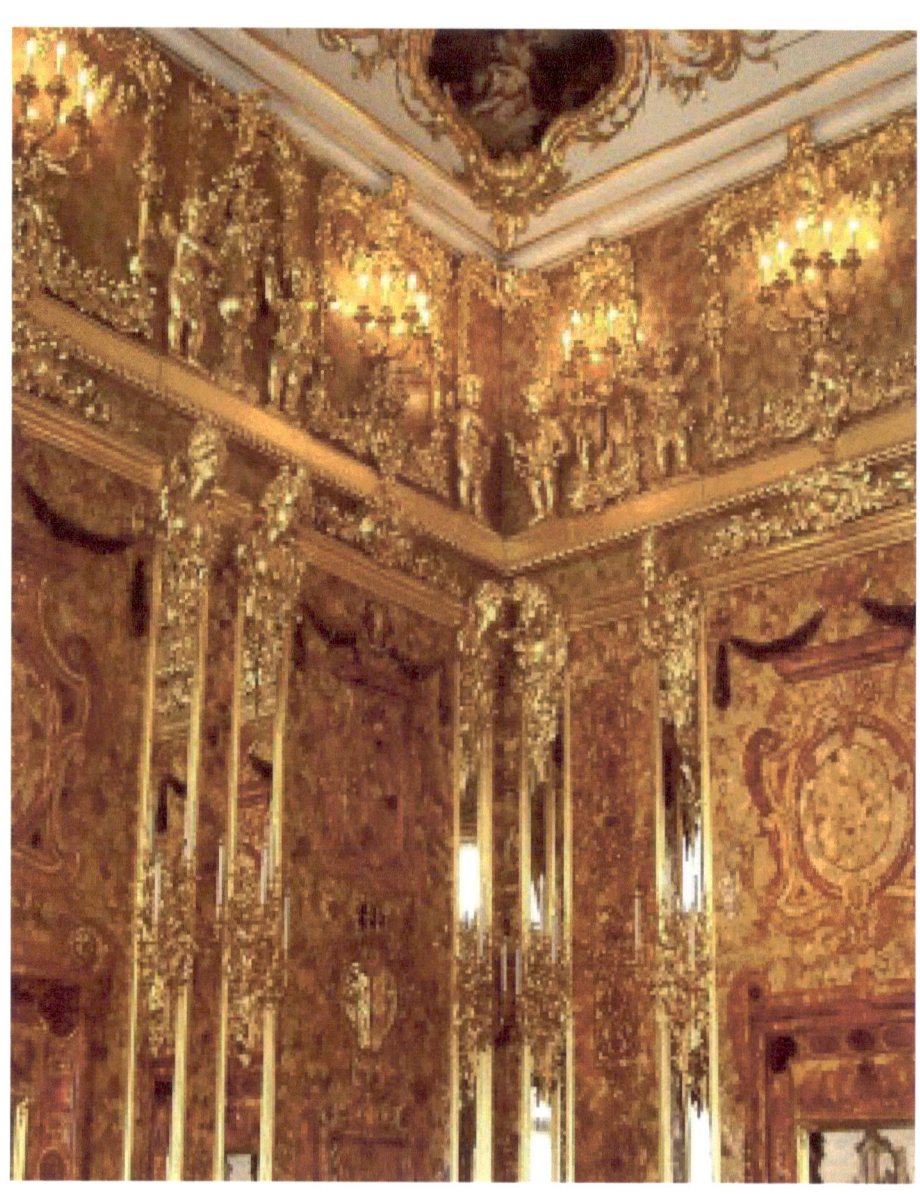

THE SEARCH FOR FOREVER AMBER

Presented to the '81 Club Monday, 20 March 2006
by **Mrs. Alan R. Marsh**

In search of Amber, the first thing that comes to mind is the forbidden novel of my youth, FOREVER AMBER, a bodice ripper set in Restoration England, written by Kathleen Winsor and published in 1944 in New York. This book, which my mother wouldn't let me read, sold 100,000 copies in its first week, was banned in Boston, and eventually sold over two million copies in hardcover. It was a best seller in 16 countries. And it has just been re-issued with a foreword by Barbara Taylor Bradford. Here is a quote from page 90: "About the first of August Amber became convinced that she was pregnant partly because she had at least one symptom, but mostly because it was *forever* on her mind."

But, no, that couldn't be the Amber for which we are searching. Perhaps it might be "Preserved in Amber" the Amber dessert wine, Vin Santo, from Tuscany…enchanting, true, but we're not there yet.

Then we find *The Independent* glowingly mentions the Amber House Bed and Breakfast in mid-Missouri near the river. But, no, that's not it!

So our search widens, and we come to Amber, the penetrating and exciting color introduced to us by Ethel Guy, the Elsie deWolfe of Kansas City. To the uninitiated, it was just a little orange room…but the glamour of an "Amber" room…what could be better?

But patience…we are are getting close. And here we are in the year 2005, traveling with friends, and discovering for ourselves…a shell of its former self…the famous Amber Room in the Catherine Palace, which is located in Pushkin, a small community on the outskirts of St. Petersburg, Russia.

And so we have arrived at last, and the mystery of Amber is opened before us.

Even though one wag said to me "Well, Amber is just pine sap, you know," I have to say it is so much more than pine sap.

Amber is a fossilized resin, not tree sap. Sap is the fluid that circulates through a plant's vascular system, while resin is the semi-solid amorphous organic substance secreted in pockets and canals through cells of the plant.

Amber is formed as a result of the fossilization of resin that takes millions of years and involves a progressive oxidation and polymerization of the original organic compounds. Although a specific time interval has not been established for this amber-developing process, the majority of amber is found within Cretaceous and Tertiary sedimentary rocks (approximately 30-90 million years old).

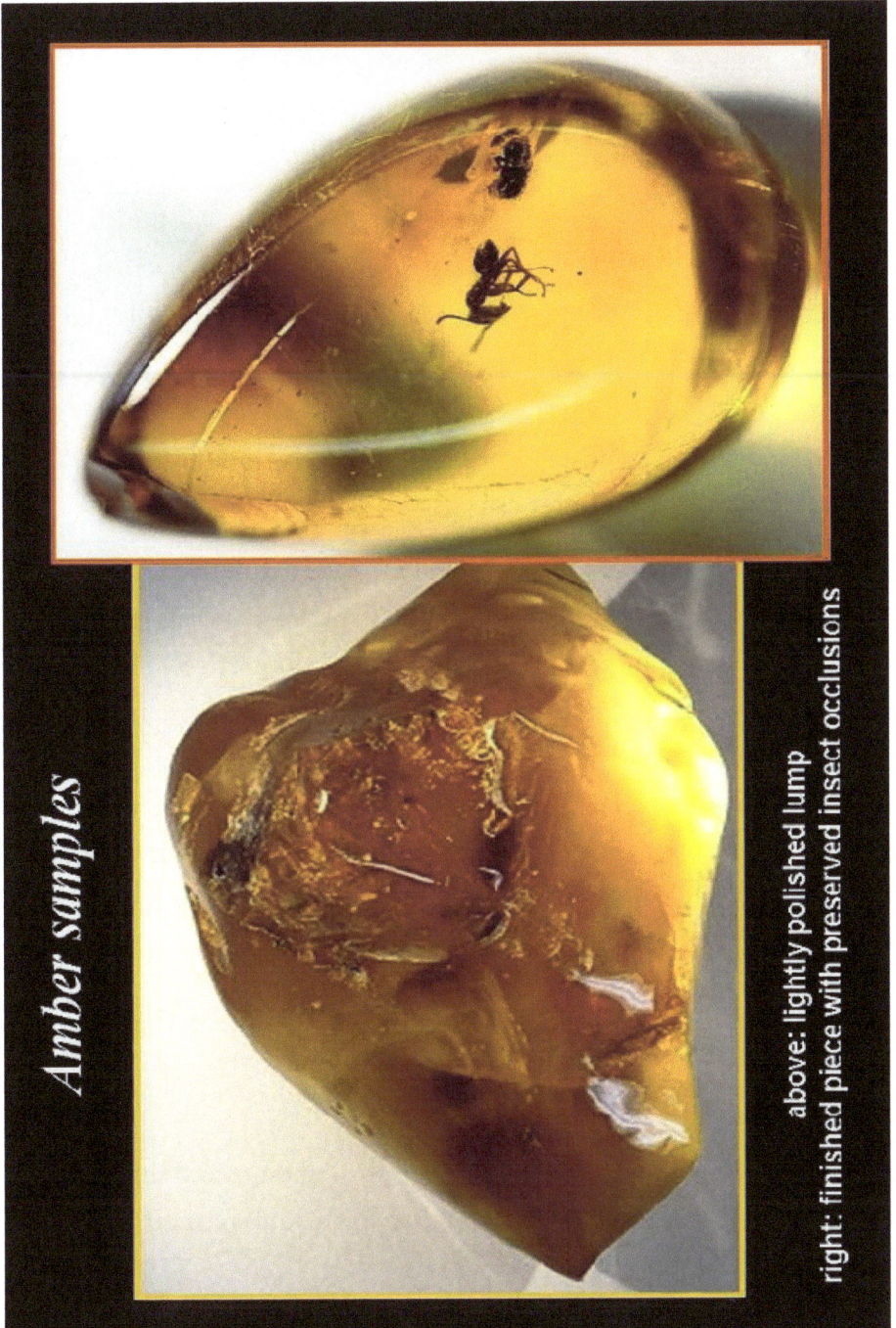

Amber samples

above: lightly polished lump
right: finished piece with preserved insect occlusions

So we can safely say that Amber developed about 50 million years ago from the resin of giant needle forests which were flooded later by the Baltic Sea. The resin of the Amber Pine flowed for thousands of years into the ground forming a layer, together with other dead plants, which was conserved for millions of years.

Ocean currents and conditions of the ground helped form these large deposits of Amber. Fierce storms would then recover the layers and bring the Amber to shore. As with coal, deep layers of sand must be removed to access the buried Amber. This process occurs mostly near the Baltic Sea, in Russia, but it also occurs in the Dominican Republic, Central America, Africa and Greece.

Civilized man was very soon attracted to the colorful, lightweight stones. By mixture of different resins and other materials, nature has developed Amber in many different colors. There is white, yellow, red and brown Amber and more seldom, even black, green and blue Amber. There are also differences in transparency ranging from clear to cloudy. And just like a gold nugget, or a diamond in the rough, the raw Amber is not beautiful to behold. It is lumpy and dark and rough. The skill of Amber artisans is needed to bring forth its lightness, clarity and beauty.

Cutting and polishing Amber became a credited profession in the 17th century. Many examples of Amber furniture were created at that time.

Amber has been used as artistic material, as money and as exchange for barter, and even as medicine. Amber was said to heal because of its supernatural powers.

Laws were soon passed (probably starting in the 1500s) to protect the interests of commercial dealers and kings who were interested in searching for and selling the precious Amber. In early kingdoms, the people living near the shores were obligated to collect and to deliver Amber to the king.

The quotas were so enormous that women, children and the elderly had to go to the beach daily under all weather conditions in order to fulfill the required goal. If a person did not comply, severe punishment was the rule. Unauthorized selling of Amber was punishable by death.

One special thing about Amber is "the inclusions." "Inclusions" are tiny bits of trees, feathers, flowers, insects or lizards which have been preserved by the resin.

The most stunning artistic and valuable use of Amber is those decorations which have been created as royal gifts and to embellish royal establishments. For example, the Prussian King Friedrich I received Amber furniture as a wedding gift. This furniture, still in existence, was bought in the 1980s by a museum in Nurnberg, Germany.

Friedrich I took Amber artistry to a new level by commissioning a giant wall cover for a gallery in the Charlottenburg Palace in Berlin. In 1707 this task was transferred to the Amber masters Ernst Schacht and Gottfried Turow from Danzig. And by 1712 this ambitious Amber wall cover was shown in the gallery in the Berlin castle.

And now we come to the famous Amber Room of Peter the Great. When Tsar Peter laid eyes on the Amber wall cover in Berlin, it is said that he admired the room greatly. When Friedrich I died in 1715, his 25 year old son Friedrich Wilhelm I ascended the throne.

Friedrich Wilhelm I was not an art lover like his father, but was known as the "Soldier King". So it came to pass that when Friedrich Wilhelm I visited Tsar Peter for political reasons, seeking his support in a project of war…basically to work together to get rid of the Swedish, he found it expedient to give the Amber Room wall cover to Peter the Great.

The Amber Room, then, originally came from Berlin to St. Petersburg. It was shipped as a royal gift packed in 18 large boxes traveling by boat and by sleigh, and was installed in the Winter Palace in St. Petersburg (later the Hermitage museum) as part of the art collection of Russian and Western European artists.

Later it was moved to the Catherine Palace in Pushkin, a small city outside of St. Petersburg, where it assumed its fabled position as "The Amber Room." There the famous Italian architect Bartolomeo Rastrellli created a room of extraordinary beauty.

As enhanced, modified and tweaked by Rastrelli, the Amber Room in its most glorious incarnation was 196 feet of total wall length and 20 feet tall. Rastrelli added 24 large mirrors from Venice of which a pair of each bordered the twelve Amber panels. The socket pieces of the mirrors were created out of amber as well. The room had three doors.

Above the main door was a lintel support of Amber and above the other doors the supports were wood covered with gold. The white door also had wood decorations covered with gold.

The Amber Room existed in this final, and most splendid form, from 1763 until 1941. During that time very few people had the pleasure of seeing the room.

The entire decoration of the Amber Room left a warm inviting sensation no matter if under sunlight or artificial light. Most likely the Amber Room reminded one of marble, but without the cold impression of marble. The Amber room was more precious than the most elaborate wooden cover. When daylight was shining through the wide windows, it replaced the light of hundreds of candles, and created thousands of reflections in the mirrors. This light made the multicolored Amber more beautiful than gold and created a deeply lasting impression, never forgotten by anyone who saw it.

On 22 June 1941 Hitler's Germany invaded Russia. The giant machinery of war rolled into the country. German organizations involved in the war also included several units specializing in culture and art…with many years of experience in looting. Their leaders, mostly art scientists, had carefully planned the largest and most perfect plundering of Russia, just like the military divisions. Since the war began, headquarters of the Wehrmacht had been focused on all valuable objects needed to satisfy the requirements of the Hitler regime.

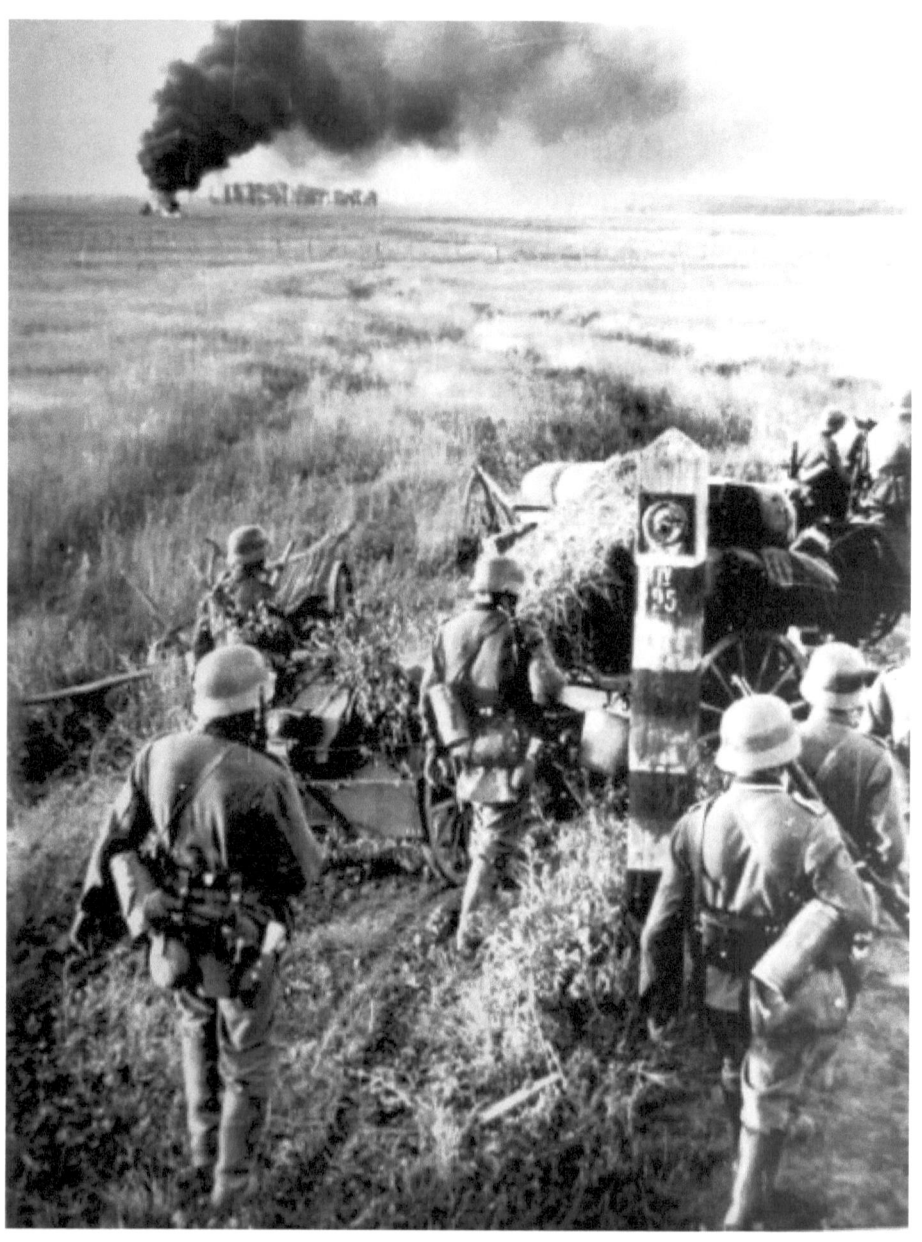

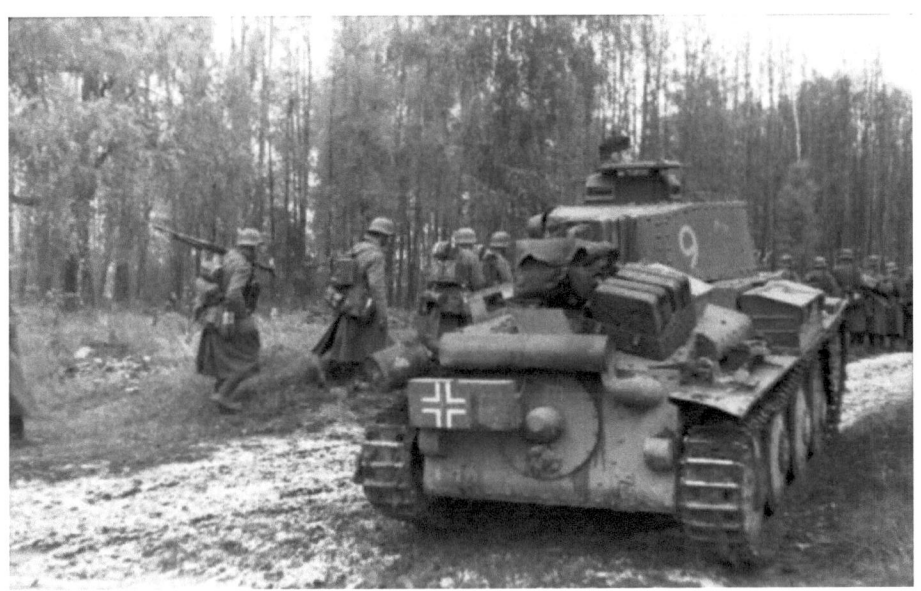

Hitler was interested in the valuable artifacts to be found in Russia. In fighting the war, the Russian defenders did not have the chance to protect the countless treasures in the castles and museums in and near St. Petersburg which were home to an enormous cache of art. Every man and every method of transport was needed for defense.

For the Russians to remove all the precious items would have required many complete trains. For example, Peterhof alone had 34,214 paintings, art works and sculptures as well as 11,700 valuable books.

Keep in mind that the Russians held the Germans from actually invading the city of St. Petersburg during the three year period called "the siege of Leningrad," which was the name of St. Petersburg at that time. Destruction of art objects did occur from the bombing of St. Petersburg.

Only some of the most valuable items could be removed to the Hermitage in St. Petersburg. Some other items were buried at the last minute. In Pushkin, women packed 20,000 items as fast as possible. Some were sent to the Urals and some to St. Petersburg to the cellars of St. Isaak's Cathedral. Among these items were some exhibition pieces of the Amber Room.

It was impossible for the women to take down the entire wall cover, which is why the curator of the Amber Room, Anatoly Kuchumov, left the priceless panels in place, thinly disguised under sheaths of painted paper, gauze and cotton. But the Nazis were nothing if not efficient in their rapacity. For certain well-briefed troops on the scene, the Amber Room was as obvious as a beacon. It is thought that the paper on the walls was also to prevent pieces from falling out in the event of bombing. A huge number of valuable art treasures still remained in Pushkin.

In mid-September, the Nazis arrived in Pushkin, with its Alexander Palace and the Catherine Palace. Strong divisions had been sent to Pushkin…the 1st Tank Division and the SS Police Division. On 16 September they reached the Catherine Palace. A bomb had hit the palace and damaged the large room and also the rooms next to it. In late September 1941 the SS Police Division continued its attack on the northern part of Pushkin. The Catherine Palace was occupied by the Wehrmacht with the 18th Army Corps, the 16th Army Corps and the 21st Tank Corps as well as parts of the 96th and 121st Infantry Divisions. These invading German soldiers used the valuable furniture from the 17th, 18th and 19th centuries to sit on or sleep on.

An eyewitness reports: "The castle was almost not damaged. Only one hit had caused some damage. The Russians could not finish evacuating all artwork. Floors had been covered with sand and vases had been filled with water.

The Germans did not care about the furniture of the castle…I saw them sleeping with dirty boots on the valuable furniture. Finally I got to the Amber Room whose walls were covered with thick paper. I saw two soldiers removing the paper from the wall. They found the shining Amber artwork, the frame of a picture.

When they took their rifles to break souvenirs from the wall, I stopped them. The next day the Amber Room looked more damaged. Much paper had been removed and pieces had been broken off."

And this is where the mystery of what happened to the Amber Room begins.

The fact is, the Amber Room was stolen from the Catherine Palace in Pushkin and sent to Konigsberg, a Prussian seaport. Konigsberg, which was controlled by the Germans, was a rare seaport on the Baltic Sea which did not freeze over in winter. The Amber Room was packed in boxes and loaded on 18 trucks. Information gleaned from reports of the time tells us that it did arrive in Konigsberg under the care of Dr. Alfred Rohde.

During this time members of the Nazi art looting squads came forward to register some of the artwork in order to start transporting it. It was necessary to register the artwork because they needed the permit of the Oberprasident since transport of art was not allowed during heavy fighting

Because of this permit request, we have some clues today as to what happened to the Amber Room.

The Amber Room together with the parquet floor and the doors had been removed and packed under the supervision of Nazi museum experts and art scientists in uniform. Thanks to the notice in the permit, offenders' names are known. Also "Wall cover of the Amber Room" was named in the permit, which shows it was included in the shipment. And the destination Kongisberg was known already. The note was made that Kongisberg was a suitable destination because the Amber room was originally made there.

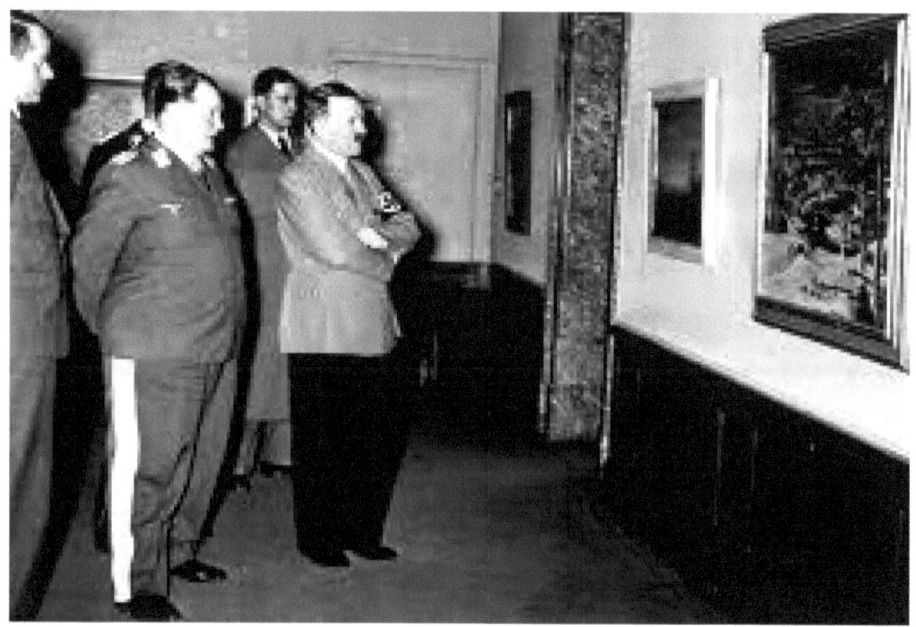

This is why Dr. Alfred Rohde, director of the Konigsberg Museum writes in one of his articles that the Amber Room "returned to its true home, the place where it was made and where it belongs." So what happened now after October 1941 to the Amber Room?

We know that Dr. Rohde worked intensively with it. This gave him the unique opportunity to find what had been made, repaired or restored of any part during the time it was in Russia. For a man like Dr. Rohde, whose whole life was filled with the study of the Amber Room, it was like a dream come true.

In the meantime, in Konigsberg, a home was prepared for the Amber Room. A wall was removed on the third floor of the Konigsberg castle to create a room similar to the room in the Catherine Palace. However it was rectangular instead of square so it was necessary to remove parts of the two opposite sides. Other changes occurred because the parquet and some candleholder parts were missing. The Amber Room as reconstructed and displayed by the Nazis in Konigsberg was a clumsy restoration, not art anymore, but it nevertheless had not lost any of its original shine and mystery. By the end of March 1942, the German work was finished and the Amber Room was on exhibit.

Mrs. Liesl Amm, a history teacher from Berlin and an eye witness as well reports: "I studied in Konigsberg 1939 until 1945 and had occasion to meet with Dr. Rohde. Dr Rohde told stories about the Amber Room in the castle of Konigsberg and since I was interested, he promised to show it to me one day, which is what he did. Then after the attacks of 19 August, Konigsberg was in ruins. After the second night of bombing I went downtown to look for friends.

Around lunchtime I arrived at the castle and met Dr. Rohde. He looked totally confused and his face was white. We greeted each other and my first question was: What happened? His answer: "Everything destroyed".

He took me into hidden cellars of the castle where I saw something like honey with burned wooden pieces in between. Later on, we never ever spoke about the Amber Room again."

At this point in history, the Amber room becomes the stuff of mystery and subsequent reports are confused, contradictory, and probably bogus. For example:

The inspector of the Konigsberg castle wrote in a diary that the Amber Room had been removed and packed after a fire in the castle in February 1944. It had been moved to the cellars where he saw it undamaged after the destruction of the castle in August 1944.

Eyewitness Professor Dr. Gerhard Strauss, art historian, says "I came to the Konigsberg castle on the second day after the bomb attack of 29 August 1944 and met Dr. Rohde. He told me that the Amber Room in the cellars would have survived the attack.

It was standing in boxes outside and Dr. Rohde just wanted to evacuate it to some rooms in the northern part of the castle."

Dr. Rhodes in his own statement writes: "Please tell the world that the Amber Room has not been damaged, except six socket parts."

And on and on…many contradictions.

The Amber Room, Amber parts or iron parts holding some elements together, were never seen during the investigation…the Amber Room

did not burn. It was last seen in the spring of 1944 and all trace has been lost…shrouded in the mystery of the past.

But the mystique of the Amber room lives on.

In modern day Russia, the enormous amount of restoration that has been accomplished by the Russian people, and their artisans, is nothing short of miraculous. For a country as ravaged by war and by its own leaders (Stalin and Lenin for example) as Russia, the country full of strong and dedicated and long enduring peasant stock has worked feverishly to restore as much of the opulence of Catherine's and Peter's Russia as possible. So today palace after palace gleams with gold leaf, and fresh yellow and white and blue paint, marble, parquet, Dutch tiles, gloriously opulent and truly over the top decadent design. The interesting part is that so much of that opulence was destroyed by peasants in the overthrow of the last Tsar, and is a sign of hated decadence of the ruling class, but now that same peasant class is working to restore as much as possible…why? Because it is a truly magnetic draw for tourists from other countries and in spite of themselves, there is a civic pride in its rich opulence.

And in this restoration process, the Amber Room has been rebuilt at the Catherine Palace in all its perfect glory.

The restoring artists had one reference photograph from which to work, and every single panel is new and newly created to form the beauty that now exists.

Today, stepping inside the Amber Room in the Catherine Palace museum is like slipping into a fairy tale – it's an Aladdin's cave!

Soaring walls bloom with polished shards of Amber – blood red, honey blond, milky gold – inset with jeweled mosaics and gilded trim. The new Amber Room was opened May 2003 by President Vladimir Putin in an emotional ceremony, and was attended by major press across Europe.

But as with many fairy tales, especially Russian ones, there is a dark side to the Amber Room too, a shadow of legend and open-ended mystery.

The mystery surrounding the fate of the original Amber Room is to the Russians what UFOs and the Bermuda Triangle are to the West. The mystery has attracted an international mélange of politicians, filmmakers, ex-Nazis, treasure divers, art historians and freelance conspiracy paranoids. The Amber Room files of the Stasi, the former East German secret police, run to some 180,000 pages. Internet sites raise virtual eyebrows over the supposed curse that has caused the suspicious deaths of several characters in the Amber Room story:

About Alfred Rohde, director of the Konigsberg Castle Museum: As the Soviet army closed in on Konigsberg in 1943, Alfred Rohde and his wife elected to stay on. Some have interpreted this as meaning that Rohde wouldn't abandon the prize that had become his obsession – in a hiding place perhaps only he knew. The KGB was curious to explore his thinking as well, but got no answers. Then one morning the Rohdes failed to arrive for a follow-up interrogation session. State security was informed that the couple had suddenly died the night before from typhus. Then events began to take on the hazy look that would bedevil future Amber Room investigators: When the KGB went to examine

the Rohdes' bodies, they had disappeared. The doctor who signed their death certificate had also vanished forever.

Then there was the high-ranking Russian intelligence officer, General Gusev, who died in a mysterious car crash after it was revealed that he had been a source for a journalist investigating the Amber Room.

Or the most famous Amber Room hunter of all, Georg Stein, who was found naked in the middle of a German forest, his stomach laid open by a scalpel.

Not to mention the absurd…but are they really absurd?…"conspiracy theories" about what happened to the Amber Room…such as…

Stalin actually had a second Amber Room and the Germans stole a fake;

<div align="center">Or</div>

It was buried in a salt mine by the Gestapo, who then killed the soldiers who moved it and sealed them inside

<div align="center">Or</div>

It was dismantled and sold in pieces to American soldiers

<div align="center">Or</div>

It is in the collection of a shadowy art dealer or Nazi sympathizer group or an Ex-Soviet military group

A German investigator named Helmu Gansel claimed that former SS officers in Brazil have pointed to a silver mine south of Berlin

<div align="center">Or</div>

The mayor of the Lithuanian town of Neringa believes it lies beneath a nearby lagoon.

Now this following part is proven true:

A few pieces of the Amber Room have actually surfaced in recent years. A German police sting operation in Bremen in 1997 turned up one of the Amber Room's four jeweled Florentine mosaic panels. Originally presented by Maria Theresa of Austria, the elaborate panels depicted the five senses in agate, onyx, opal and lapis lazuli. This one, combining Smell and Touch, was authenticated as the genuine article. Unfortunately, the seller, son of a deceased Wehrmacht soldier, had no idea how his father had obtained or stolen it.

It appears likely that the mosaic and an Amber Room cabinet that turned up about the same time were stolen separately during the confusion of the war.

Or one more absurd theory just for good measure:

The Nazis sent the Amber Room out on a submarine from Konigsberg with just enough oxygen and fuel to get to a certain place and then run out. It is still waiting there on the bottom of the Baltic, the coordinates now forgotten. No mention made of whether it was manned by humans or not.

In the meantime, the search for the REAL, the original, Amber Room goes on…and on.

If you Google www.amberroom.com, you will find The Amber Room Organization which was founded in 1988 with the mission of investigating the Amber Room and other objects of art and culture missing since WWII. Their treatise makes for interesting reading.

Their list of suspicious hiding places of the lost Amber Room includes:

 Breweries

 Bunkers

 Buried

 Castles

 Caves

 Mines

 Oceans

 Tunnels

And these enterprising people have also put together Treasure Hunt group trips for those interested in looking for the missing Amber Room themselves. And the bottom line is *"Please send a donation!"*

Now the last obvious question: What happens to the new Amber Room if the old Amber Room is found? "We believe it will be found" says the director of the Catherine Palace museum, Mr. Sautov. "But it could be exhibited only in the state it's found in, and it's in poor condition. Besides, who could afford to restore it now that so much has been spent on the new Amber Room?"

Google gives us 66,700,000 hits for "Amber Room"…and now we know more than we need to about the many forms of Amber…

Light, lovely, glowing, and full of mystery.

This concludes my report except for the following post script:

An interesting update: Coming soon (December) to a theatre near you:

THE MONUMENTS MEN

Directed by George Clooney. With Matt Damon, George Clooney, Cate Blanchett, John Goodman. In a race against time, a crew of art historians and museum curators unites to recover renown works of art stolen by Nazis before Hitler destroys them....

Check your Movie Showtimes!

The End

ABOUT THE AUTHOR

Joan Marsh is a member of the '81 Club of Kansas City, Missouri, which was formed in 1881 for the purpose of presenting scholarly papers to the membership, avoiding the forbidden topics of the Civil War, politics and religion. This intimate look at the history of the fabled Amber Room is one of many '81 Club papers spotlighting such stars as James Abbott McNeill Whistler, Madame Curie, Madame Chiang Kai-shek, Nora Ephron, Isabella Stewart Gardner, David Douglas Duncan, Robert Edsel, eventually totaling a body of work of 25 titles, better known as

The THRILLING READING LIVING VICARIOUSLY Series.

If 25 is the magic number for publications by Joan Marsh, then please skip ahead for a complete listing of the 25 exquisite children's books that form the nucleus of her life's work as a publisher, the.

CHARACTER EDUCATION PICTURE BOOKS for CHILDREN Series.

Joan attended the University of Missouri and holds a B.A. from Texas Tech University. Her major was English, and as night follows the day, led to her 43 year career in publishing education programs for children. Joan and Alan Marsh founded MarshFilm Enterprises, Inc. dba MarshMedia in 1969. The Marshes live in Kansas City, Missouri, where they raised their two sons. Those sons and their families, including eight grandchildren, who live all over the world, were the inspiration for many of the childrens' stories.

The family motto is *Carpe Diem*. Seize the Day!

THRILLING READING
LIVING VICARIOUSLY SERIES
Kindle Edition and Paperback

POETRY REVISITED EDNA ST. VINCENT MILLAY (Volume 1)
https://amzn.com/B0143UTP2Q

Be the first to rediscover the distinguished and celebrated American poet Edna St. Vincent Millay, whose lines

> *"My candle burns at both ends.*
> *It cannot last the night.*
> *But ah my foes and oh, my friends,*
> *It gives a lovely light"*

are still burning today with the same lyrical urgency

Not suitable for children, catnip for adults

Read this slim volume for a quick pickmeup while traveling abroad.

> *"Dark brown is the river,*
> *Golden is the sand"*
> *for the little children*

Edna makes her debut moving into the 21st century as fresh and saucy as ever!

THE SEARCH FOR FOREVER AMBER (Volume 2)
https://amzn.com/B014LRVMX6

A mini course in Russian history, amber history, Monuments Men, and the continuing mystery of what actually happened to the original Amber Room in the throes of World War II. All news to the casual observer.

The Mystery unfolds...

While traveling with the Met along the Baltic's Amber Coast en route to St. Petersburg aboard Sea Cloud II use this mini volume white paper to prep yourself on the story of "Amber."

Even though one wag said to me "Well, Amber is just pine sap, you know," I have to say it is so so much more than pine sap!

Today, stepping inside the Amber Room in the Catherine Palace museum is like slipping into a fairy tale - it's an Aladdin's cave!

Discover for yourself the breathtaking beauty of glowing amber, cut and polished, coming to the light from its lumpy, dark, rough birth.

But as with many fairy tales, especially Russian ones, there is a dark side to the Amber Room too, a shadow of legend and open-ended mystery.

And so we embark together on the search for forever Amber.

MARGARET QUEEN OF SCOTLAND (Volume 3)
https://amzn.com/B014V0MJGC

For all the precious Margarets in your family…

This compelling story about the incredible Medieval Queen Margaret is just in time for wonderful spring, summer, fall or winter reading. What better than to meet this modern feminist living in the 11th century.

Margaret makes her debut - moving into the 21st century - as fresh and enchanting as ever… so be the first to re-discover Margaret the Medieval Queen of Scotland so advanced for her place in history..

Our all time favorite...brilliant and beautiful Margaret

SAYING GOOD BYE TO NORA EPHRON *(Volume 4)*
https://amzn.com/B015LFRP4C

Everyone loves Nora Ephron, right? Especially her divine recipes. Especially her clever movies. Especially her joie di vivre.

This quick and easy to read paper is a sweeping mini-bio of Nora that slides gracefully into her last six years on this earth, when no one knew what was in store for her.

As Frank Rich wrote in New York Magazine "What doesn't matter is whether we got to say good-bye or not. What does matter is that she was here for those she loved and those who loved her, and that now, while we were napping, she has gone."

Witty and clever Nora…a powerful writer bringing joy to all her readers

#EVERYTHING IS COPY

A treat is in store for her fans.

Exit Laughing…Nora Ephron's dramatic departure…and when we looked the other way, she left the room…

Nora is still with us…her humor and joie de vivre living on!

THE PEACOCK ROOM and WHISTLER'S MOTHER *(Volume 5)*
https://amzn.com/B017V4XSBU

A personalized look at the life and times of James Abbott McNeill Whistler…

During the course of his work for the art patron, Frederick R. Leyland, a Liverpool ship owner, the following transpired:

"That gave the excitable Whistler a clear field. Alone in the house, he more than touched up the room with a little gold paint. He let his imagination run wild with peacock feather designs on the ceiling, ornate peacocks in gilded paint on the shutters, and around the walls.

'Well, you know, I just painted on and on. I went on – without design or sketch – putting in every touch with such freedom…and the harmony blue and gold developing, you know, I forgot everything in my joy of it.'

And, most shockingly, he painted over the leather walls.

Now about those leather walls. The leather had been bought by Thomas Jekyll at great expense to Mr. Leyland. It had been part of the dowry of Catherine of Aragon who brought it from Spain. It was richly embossed and trimmed, and important in its own right.

Whistler had covered all the visible rich antique Spanish leather completely with a thick coat of peacock blue paint. "

DISCOVERING ALVIN A MAN OF MARK AND MYSTERY (Volume 6)
http://amzn.com/B018PN1V6U

> "The photographic career of Alvin Langdon Coburn appears before our eyes like a brief time exposure through a fast lens."
>
> He was an amazing modern photographer working a century ahead of his time, inventing cutting edge techniques along the way…all in the first 24 years of his life. Then enjoy a full report of what came after that in the remaining 60 years. It's an engrossing and fresh story.
>
> Mrs. Marsh's paper explores the relationship between photography and fine art through the lens of the long forgotten photographer Alvin Langdon Coburn, who was born in 1882, with a nod along the way to the Spencer Art Reference Library and the cult of Freemasonry, and the current heralded fine art photographer Matthew Pillsbury.

THE LAST EMPRESS MADAME CHIANG KAI-SHEK (Volume 7)
http://amzn.com/B01IKWLPA8

> She had been glamorous. She had been sexy and compelling. She had dreams of ruling the world. Sometimes she was known as the Dragon Lady, in another life she was known as Soong Mei-ling, one of the three beautiful, rich and powerful Soong Sisters.
>
> She was Madame Chiang Kai-shek…
>
> Admirable…or notorious…moral or amoral…calculating and determined…charming and patriotic…Christian…all of those things, and more… Madame Chiang Kai-shek

DAVID DOUGLAS DUNCAN PHOTOGRAPHER EXTRAORDINAIRE *(Volume 8)*

http://amzn.com/B01IUNNRG2

Happy Birthday to David Douglas Duncan! Celebrating his 100th birthday, still going strong, living in Castellaras, France, and enjoying worldwide recognition.

The accumulated vision of a matchless eye…from iconic wartime photos to intensely personal at-home images of Picasso at play and at work…much of Duncan's prolific body of work is archived and made available to the public through The Harry Ransom Center at the University of Texas at Austin thanks to the foresight and generosity of Stanley Marcus.

This '81 Club paper, first presented in 2005, still reverberates with vitality, as accurate and interesting today as it was then. Mr. Duncan's work is a living history of war and the nomad life.

MADAME CURIE as REIMAGINED by LAUREN REDNISS (Volume 9)
http://amzn.com/B01K5Z0XXI

The imaginative re-telling of the well known story of Marie and Pierre Curie, their passionate love, their passionate research, their brilliant discovery, blooms in the book Radioactive...Marie & Pierre Curie A Tale of Love and Fallout by Lauren Redniss.

Radioactivity had made the Curies immortal. Now it was killing them.

Early on in our story, we are seeing the lack of fear as Marie and Pierre work to discover radium...not being afraid to be close to it, nor touch it, and treating it like a pet that might be cuddled and kept by Marie's pillow...so, it must be assumed, they did not yet sense the danger of it.

Marie wrote: "Crystals of barium chloride containing radium are colorless, but when the proportion of radium becomes greater, they have a yellow color...after some hours, verging on orange, and sometimes a beautiful pink."

Again we see her fearless enjoyment of the beauties of radium.

"The flame spectrum of radium contains two beautiful red bands, one line in the blue-green, and two faint lines in the violet."

And later...in the spring of 1910 a flush appeared over Marie's cheeks. She pinned a flower to her dress. She had taken a lover.

But then the magic of X-ray in wartime...

No longer were doctors performing blind exploratory surgeries on already damaged bodies.

It's a breathtaking and important story.

Marie and Pierre Curie sleep today in Paris's splendid necropolis, the Pantheon.

Held in the Bibliotheque Nationale, the Curies' laboratory notebooks are still radioactive, setting Geiger counters clicking 100 years on.

CHARACTER EDUCATION PICTURE BOOKS for CHILDREN SERIES
Kindle Edition

These ebooks form a series of luminously illustrated children's stories, each with a timeless animal protagonist, a compelling geographic location, an important multicultural life skills message.

Each serious lesson is embedded in an exciting colorful adventurous story.

The stories are cleverly and skillfully written by published authors with a high level of literary talent and wit. They have been edited and proofed and re-proofed to the most exacting standards of accuracy in grammar, punctuation and fact checking. They have been reviewed…pre-publication…by teachers and librarians for relevance and the power of the message.

ALOHA POTTER!
http://amzn.com/B008LZ8JH2

> "You get the idea, don't you? 'Alakuma liked to tease Potter. That might have been okay, but the things 'Alakuma said made Potter feel sort of … bad. Bad about his size. Bad about his name.
> Bad about everything."

AMAZING MALLIKA
http://amzn.com/B008C9K7OK

> "Amazingly, marching had made Mallika feel better. Her anger had melted. 'I'll never get so angry again,' she promised. 'No matter what!' But that was before the langur monkeys laughed at her."

BAILEY'S BIRTHDAY
http://amzn.com/B0083LLTHQ

> "Early the next morning, a loud CLANG! from the street below woke him.
>
> Bailey sprang to the window. 'They're delivering my presents!' he said. But all he saw were garbage collectors emptying garbage cans into their big truck.
>
> 'Haven't been good enough yet,' he decided."

BASTET
http://amzn.com/B0083V6AGQ

> "But Bastet did not follow. She stopped outside the door. She sat. She thought. She remembered everything she and Sabah had heard about Tutankhamun's mask. The dazzling gold! The ebony eyes! The jeweled cobra! The brilliant inlays of lapis-lazuli and quartz and obsidian! And in her mind's eye she saw, staring up at Tutankhamun, two scrawny cats, one golden and one spotted. That was her dream, after all. Not just to see the mask, but to see it with Sabah. Together.
>
> How disloyal she had been to Sabah!"

BEA'S OWN GOOD
http://amzn.com/B0081VMGDC

> "When I awoke, I found myself in the bottom of Cati's bicycle basket. I crawled to the top to see what I could see. I was back in the bee-master's garden, and there was my hive only a few feet away! Even so, I was so cold that I could not fly to the hive.
>
> Suddenly there was the bee-master himself looking down on me.
>
> 'I will help you, my little friend,' he said."

CLARISSA
http://amzn.com/ B008WX9TOA

> "Fiona and Tessy were always pushing Clarissa around. They nudged her away from the sweet patches of clover she found. They crowded her from the shade of the old oak tree. They shoved ahead of her at the feeding trough. But Clarissa never complained. It seemed to her that you had to be big and bossy like Fiona or beautiful like Tessy to get what you wanted. And she was neither.
>
> Clarissa was just a plain brown cow."

EMILY BREAKS FREE
http://amzn.com/B0085RPUF0

> "Emily looked at Cotton's stricken face and then at Spike's expectant one. She gobbled the biscuit down, but it didn't taste as good as she had thought it would. 'I declare!' cried Cotton.
>
> 'I do believe the dogs in this town are the meanest ol' dogs I have ever had the misfortune to encounter!'"

FEATHERS AT LAS FLORES
http://amzn.com/B008FRH7HY

> "Then, who should show up but Julio himself.
>
> 'What's going on here?' he asks.
>
> 'Maybe you should ask Feathers,' says Angela. Everyone's eyes turn on me. I mean, I've learned my lesson. And I'm hoping everybody else has too. What am I supposed to say? Then it comes to me.
>
> 'HAVA CUPPA COFFEE!' I squawk as loud as I can. It seems the only safe thing to say.
>
> Know what I mean?"

FOLLOWING ISABELLA
http://amzn.com/B008257QNE

> "Then Isabella saw it – smoke boiling up from over the hill. A wildfire raged, sparked by the lightning. Without thinking, Isabella called out, 'Don't run! Follow me!' She turned to Pedro with panic in her eyes. Which way? 'Isabella,' he said, 'you must find the way home!'
>
> She thought quickly…
>
> Oh, what if she chose the wrong way?"

GUMBO GOES DOWNTOWN
http://amzn.com/B008HK4KH4

> "I fell asleep thinking about the dog with no home and thinking about my home and wondering if this might be the night an intruder came, with no watchdog there to warn Gus."

HANA'S YEAR
http://amzn.com/B008CXAPKW

> "How grateful Kenji and his grandmother were that Hana had saved the kimono cloth. Hana would always remember that day – how grandmother patted the top of her head and how Kenji bowed to her once again.
>
> 'O-saru-sama,' he said. 'Very honorable monkey.'"

INGER'S PROMISE
http://amzn.com/B008IVMGQ4

> "For the rest of the festival week, Inger was too embarrassed to talk to anyone.
>
> Every whisper, every giggle, every sideways glance – Inger was sure they were all aimed at him.
>
> How would he ever make up for the wedding-day disaster?"

JACKSON'S PLAN
http://amzn.com/B008CRBAUM

> "It hadn't been easy, but Jackson had stuck to his plan, and he had succeeded. He grinned a long froggy grin and returned to his dreams of dragonflies and beetles."

JOMO AND MATA
http://amzn.com/B008HLK1O4

> "An hour later, Jomo woke with a start. He caught a sharp scent that made his skin prickle. He raised his trunk in the air. Jomo was sure he could smell a lion nearby.
>
> Then he saw two gold eyes peering at him from the brush!"

KIKI AND THE CUCKOO
http://amzn.com/B008CADSUY

> "Suddenly the small door opened and someone was pulling Kiki gently out of the box. A woman said, 'How did a bird get caught in our cuckoo clock?' A girl stood beside her. 'It's a meadowlark,' the woman said, holding Kiki in her gloved hand.
>
> 'Let me see,' whispered the girl. 'Oh,' she sighed, 'are they all as pretty?'
>
> 'No,' thought Kiki."

KYLIE'S CONCERT
http://amzn.com/B008DY0M8A

> "As Kylie traveled along, the way grew strange and mysterious."

LUDMILA'S WAY
http://amzn.com/B008679S5W

> "My dear Babushkas," said Ludmila. "Our Pavel has had only bits of grass and a few bugs to eat today. Won't you share?"
>
> "Nyet," they said.
>
> "Babushkas, might this not be a chance for a new beginning? We could put the old way behind us! We could share and share alike! That is the best way, don't you agree? Pavel? Babushkas?"
>
> "Da!" said hungry Pavel, nodding hopefully at the Babushkas.

MOLLY'S MAGIC
http://amzn.com/B008GESVVW

> "'I can't believe we're so busy,' Mrs. O'Malley said. 'It's like magic!'
>
> 'Such a clever sign!' said a visitor. 'Why, that pig of yours is irresistible! I had to come and see your farm, and I'm glad I did. This tea is delicious!'
>
> 'Pig?' said Mrs. O'Malley, looking towards the sty. 'What pig?'"

PAPA PICCOLO
http://amzn.com/B008J9X1JG

> "When nighttime came to the canals and narrow streets of Venice and almost everyone went **inside** and turned on the lights, Piccolo went **out**.
>
> The dark was full of possibilities. Who knew what Piccolo might find inside that open window? Perhaps a shiny trinket, a dish of cream, or a pretty yellow canary?

PEQUENA THE BURRO
http://amzn.com/B008HLK4PK

> "From somewhere in the crowd, Pequena thought she heard a familiar voice. 'There is no such thing as only a burro.' 'Just a little more' – Senora Alvarez called. Pequena pressed on. The heat from the sun and the heat from the effort were nearly suffocating.
> And then Pequena felt the rope suddenly go slack."

PLATO'S JOURNEY
http://amzn.com/B0088TQZZE

> In this age of white lies and casual deceptions, Plato's story will make readers of all ages value the simple truth.

STANLEY'S "THIS IS THE LIFE!"
http://amzn.com/B008D6Q2J6

> "All day Stanley hid beneath a bridge. The early summer breeze smelled of lupines and clover. A grasshopper jumped from a dandelion onto Stanley's nose. Lying in the cool shade, Stanley thought about home. Then his nose twitched.
> **I know that smell**, Stanley thought. **Popcorn**! He could almost taste the butter and salt."

TESSA ON HER OWN
http://amzn.com/B008EEQ1AC

> "At first, Tessa could barely catch enough to keep herself from starving, but in time, she became an excellent hunter. Tessa felt proud to be a fox.
> 'Nobody can call me lazy now!' she said, carefully grooming her full russet tail."

THANK YOU, MEILING
http://amzn.com/B008HLK5VI

> "Song Hai's friend Go Ming runs to sit beside him. I see a wistful look flicker across Song Hai's face. He places his bun back on its wrapping, then tears it in half.
>
> 'Here Go Ming,' he says. 'Please share my snack. It's too much for me to eat alone.'"

TOAD IN TOWN
http://amzn.com/B008257T72

> "When toad awoke it was nearly dark. He rustled out of his leafy bed. Bright lights loomed up and rushed by with a roar. Then more. And more.
>
> 'Where AM I?' he cried. 'And how will I ever get back home?'
>
> All that night toad stayed in the dark, always looking for a familiar landmark, sniffing the air for the smell of the meadow, listening for the sound of the brook
>
> The next day and night were the same. And the next.
>
> There finally came a night when toad knew that his world had changed forever.
>
> Toad would have to make himself a new home in this new world."

Joan's Book Collections

Contact Joan Marsh at email: joanmarsh@aol.com

JOAN'S THRILLING READING LIVING VICARIOUSLY Series
https://www.ebooksbyjoanmarsh.com/

JOAN'S CHARACTER EDUCATION PICTURE BOOKS
for CHILDREN Series
https://www.childrensebooksbyjoan.com

JOAN'S AMAZON AUTHOR PAGE
https://www.amazon.com/author/joanmarsh

JOAN'S FACEBOOK PAGE and TWITTER ACCOUNT
https://www.facebook.com/people/Joan-K-Marsh/100011486057355
https://www.twitter.com/@joanmarsh3

www.ingramcontent.com/pod-product-compliance
Lightning Source LLC
Chambersburg PA
CBHW041209180526
45172CB00006B/1222